THE MARRIAGE OF HEAVEN AND HELL

IN FULL COLOR

WILLIAM BLAKE

DOVER PUBLICATIONS, INC.
NEW YORK

Copyright

Published in Canada by General Publishing Company, Ltd., 30 Lesmill Road, Don Mills, Toronto, Ontario.

Published in the United Kingdom by Constable and Company, Ltd., 3 The Lanchesters, 162–164 Fulham Palace Road, London W6 9ER.

Bibliographical Note

This Dover edition, first published in 1994, is an unabridged republication of the work originally published by Blake ca. 1794. A publisher's note and the complete text of *The Marriage of Heaven and Hell* have been specially prepared for this edition.

Library of Congress Cataloging in Publication Data

Blake, William, 1757–1827.
 The marriage of Heaven and Hell : in full color / William Blake.
 p. cm.
 ISBN 0-486-28122-1 (pbk.)
 1. Blake, William, 1757–1827—Manuscripts—Facsimiles. 2. Illumination of books and manuscripts, English. 3. Manuscripts, English—Facsimiles. I. Title.
PR4144.M3 1994
821'.7—dc20 94–471
 CIP

Manufactured in the United States of America
Dover Publications, Inc., 31 East 2nd Street, Mineola, N.Y. 11501

NOTE

WILLIAM BLAKE was born in 1757, son of a London haberdasher. He received some schooling in art, first in a drawing school and later at the Royal Academy of Arts. When he was seventeen, Blake was apprenticed to the engraver James Basire. Using the skills he acquired during his apprenticeship, Blake began developing his own process of "illuminated printing"—using etched copper plates to print pages that were then colored by hand. Because this process was so time-consuming, Blake's illuminated books were printed only in limited numbers, and though Blake's method prohibited a wide circulation of his books, he nevertheless felt that it was the best forum for his poetic and philosophical writings. As can be seen in *The Marriage of Heaven and Hell,* the illuminated illustrations work together with Blake's text to add depth and resonance to the work.

The Marriage of Heaven and Hell, of which only nine copies are known to exist, was probably begun in 1789 and completed in 1790. The third of the illuminated books, *The Marriage of Heaven and Hell* is principally a prose statement of Blake's philosophic message. Often considered one of the first Romantic poets, Blake believed in the power of the imagination and in the stultifying effects of conventionality. In *The Marriage of Heaven and Hell*, these beliefs are illustrated not only by Blake's reversal of traditional notions of Good and Evil, Angels and Devils, and Heaven and Hell, but by his celebration of the tensions produced by these "contraries." Such tensions, according to Blake, are necessary to progress and creativity.

The present volume reproduces the 27 plates of *The Marriage of Heaven and Hell* as well as a transcription of the full text following the plates. Blake's spelling, punctuation and use of capital letters have been retained wherever possible.

CONTENTS

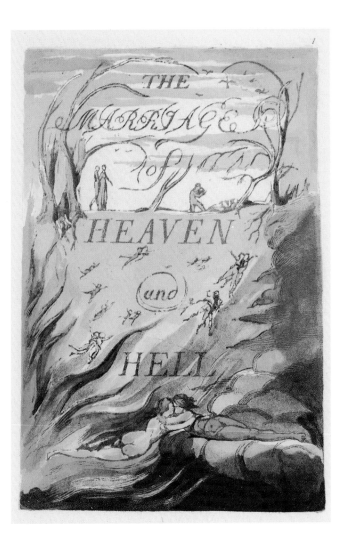

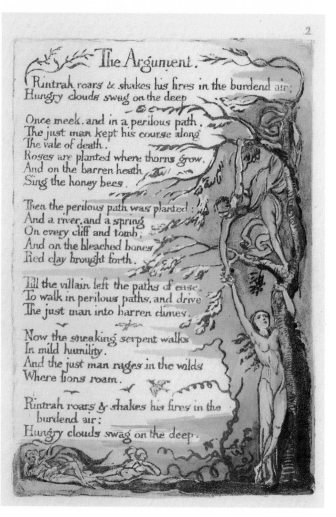

The Argument.

Rintrah roars & shakes his fires in the burdend air;
Hungry clouds swag on the deep

Once meek. and in a perilous path.
The just man kept his course along
The vale of death.
Roses are planted where thorns grow.
And on the barren heath
Sing the honey bees.

Then the perilous path was planted:
And a river, and a spring
On every cliff and tomb;
And on the bleached bones
Red clay brought forth.

Till the villain left the paths of ease.
To walk in perilous paths, and drive
The just man into barren climes.

Now the sneaking serpent walks
In mild humility.
And the just man rages in the wilds
Where lions roam.

Rintrah roars & shakes his fires in the
 burdend air:
Hungry clouds swag on the deep.



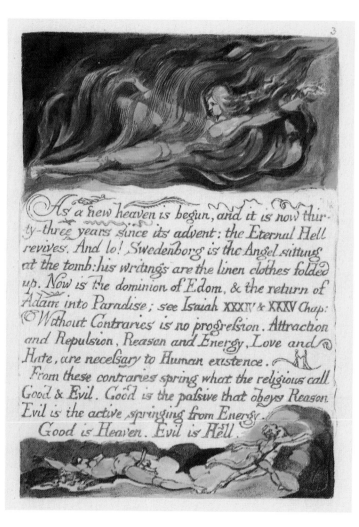

As a new heaven is begun, and it is now thir-
ty-three years since its advent: the Eternal Hell
revives. And lo! Swedenborg is the Angel sitting
at the tomb: his writings are the linen clothes folded
up. Now is the dominion of Edom, & the return of
Adam into Paradise; see Isaiah XXXIV & XXXV Chap:
Without Contraries is no progression. Attraction
and Repulsion, Reason and Energy, Love and
Hate, are necesary to Human existence.
From these contraries spring what the religious call
Good & Evil. Good is the passive that obeys Reason.
Evil is the active springing from Energy.
Good is Heaven. Evil is Hell.

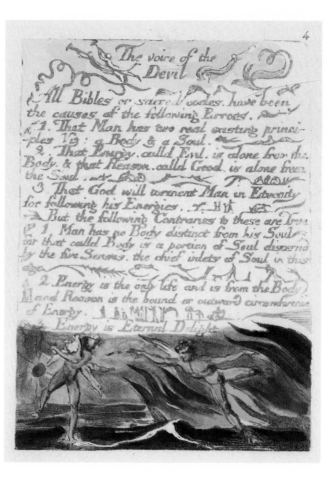

The voice of the
Devil

All Bibles or sacred codes. have been
the causes of the following Errors.

1. That Man has two real existing princi-
ples Viz: a Body & a Soul.

2. That Energy. calld Evil. is alone from the
Body. & that Reason. calld Good. is alone from
the Soul.

3 That God will torment Man in Eternity
for following his Energies.

But the following Contraries to these are True

1 Man has no Body distinct from his Soul
for that calld Body is a portion of Soul discernd
by the five Senses. the chief inlets of Soul in this
age

2. Energy is the only life and is from the Body
and Reason is the bound or outward circumference
of Energy.

3 Energy is Eternal Delight

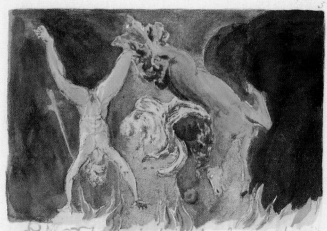

Those who restrain desire, do so because theirs is weak enough to be restrained; and the restrainer or reason usurps its place & governs the unwilling.

And being restraind it by degrees becomes passive till it is only the shadow of desire.

The history of this is written in Paradise Lost. & the Governor or Reason is calld Messiah.

And the original Archangel or possessor of the command of the heavenly host, is calld the Devil or Satan and his children are calld Sin & Death

But in the Book of Job Miltons Messiah is calld Satan.

For this history has been adopted by both parties

It indeed appeard to Reason as if Desire was cast out. but the Devils account is that the Messi-

ah fell. & formed a heaven of what he stole from the Abyss.

This is shewn in the Gospel, where he prays to the Father to send the comforter or Desire that Reason may have Ideas to build on, the Jehovah of the Bible being no other than he who dwells in flaming fire. Know that after Christs death, he became Jehovah.

But in Milton; the Father is Destiny, the Son, a Ratio of the five senses. & the Holy-ghost, Vacuum!

Note. The reason Milton wrote in fetters when he wrote of Angels & God. and at liberty when of Devils & Hell, is because he was a true Poet and of the Devils party without knowing it.

A Memorable Fancy

As I was walking among the fires of hell, delighted with the enjoyments of Genius; which to Angels look like torment and insanity. I collected some of their Proverbs: thinking that as the sayings used in a nation, mark its character. so the Proverbs of Hell, shew the nature of Infernal wisdom better than any description of buildings or garments. When I came home: on the abyss of the five sen-ses. where a flat sided, steep frowns over the present world. I saw a mighty Devil folded in black clouds, hovering on the sides of the rock. with cor-

TO

roding fires he wrote the following sentence now per-
ceived by the minds of men, & read by them on earth.

How do you know but ev'ry Bird that cuts the airy way,
Is an immense world of delight, clos'd by your senses five?

Proverbs of Hell

In seed time learn, in harvest teach, in winter enjoy.
Drive your cart and your plow over the bones of the dead.
The road of excess leads to the palace of wisdom.
Prudence is a rich ugly old maid courted by Incapacity.
He who desires but acts not, breeds pestilence.
The cut worm forgives the plow.
Dip him in the river who loves water.
A fool sees not the same tree that a wise man sees.
He whose face gives no light, shall never become a star.
Eternity is in love with the productions of time.
The busy bee has no time for sorrow.
The hours of folly are measur'd by the clock, but of wis-
dom: no clock can measure.
All wholsom food is caught without a net or a trap.
Bring out number weight & measure in a year of dearth.
No bird soars too high, if he soars with his own wings.
A dead body, revenges not injuries.
The most sublime act is to set another before you.
If the fool would persist in his folly he would become
wise.
Folly is the cloke of knavery.
Shame is Prides cloke.

Proverbs of Hell

Prisons are built with stones of Law, Brothels with
bricks of Religion.

The pride of the peacock is the glory of God.

The lust of the goat is the bounty of God.

The wrath of the lion is the wisdom of God.

The nakedness of woman is the work of God.

Excess of sorrow laughs. Excess of joy weeps.

The roaring of lions, the howling of wolves, the raging
of the stormy sea, and the destructive sword are
portions of eternity too great for the eye of man.

The fox condemns the trap, not himself.

Joys impregnate. Sorrows bring forth.

Let man wear the fell of the lion, woman the fleece of
the sheep.

The bird a nest, the spider a web, man friendship.

The selfish smiling fool, & the sullen frowning fool, shall
be both thought wise, that they may be a rod.

What is now proved was once only imagin'd.

The rat, the mouse, the fox, the rabbet; watch the roots,
the lion, the tyger, the horse, the elephant, watch
the fruits.

The cistern contains; the fountain overflows.

One thought fills immensity.

Always be ready to speak your mind, and a base man
will avoid you.

Every thing possible to be believ'd is an image of truth.

The eagle never lost so much time, as when he submit-
ted to learn of the crow.

The

Proverbs of Hell

The fox provides for himself, but God provides for the lion.

Think in the morning. Act in the noon, Eat in the even-
-ing, Sleep in the night,

He who has sufferd you to impose on him knows you.

As the plow follows words, so God rewards prayers.

The tygers of wrath are wiser than the horses of in-
Expect poison from the standing water. (-struction

You never know what is enough unless you know what is
more than enough.

Listen to the fools reproach! it is a kingly title!

The eyes of fire, the nostrils of air, the mouth of water,
the beard of earth.

The weak in courage is strong in cunning.

The apple tree never asks the beech how he shall grow,
nor the lion, the horse, how he shall take his prey.

The thankful reciever bears a plentiful harvest.

If others had not been foolish, we should be so.

The soul of sweet delight, can never be defil'd,

When thou seest an Eagle, thou seest a portion of Ge-
-nius, lift up thy head!

As the catterpiller chooses the fairest leaves to lay
her eggs on, so the priest lays his curse on
the fairest joys.

To create a little flower is the labour of ages.

Damn, braces: Bless relaxes.

The best wine is the oldest, the best water the newest.

Prayers plow not! Praises reap not!

Joys laugh not! Sorrows weep not!

The

Proverbs of Hell.

The head Sublime, the heart Pathos, the genitals Beauty
the hands & feet Proportion.

As the air to a bird or the sea to a fish, so is contempt
to the contemptible.

The crow wish'd every thing was black, the owl, that eve
ry thing was white.

Exuberance is Beauty.

If the lion was advised by the fox, he would be cunning.

Improvent makes strait roads, but the crooked roads
without Improvement, are roads of Genius.

Sooner murder an infant in its cradle than nurse unact
-ed desires

Where man is not nature is barren.

Truth can never be told so as to be understood, and
not be believd.

Enough! or Too much

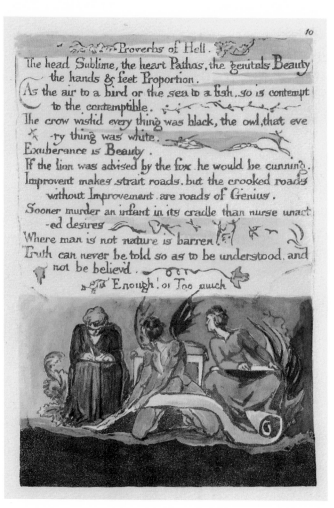

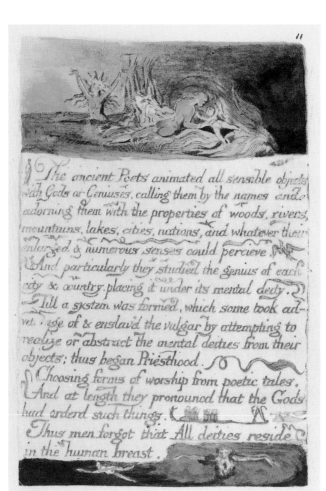

The ancient Poets animated all sensible objects with Gods or Geniuses, calling them by the names and adorning them with the properties of woods, rivers, mountains, lakes, cities, nations, and whatever their enlarged & numerous senses could perceive.

And particularly they studied the genius of each city & country, placing it under its mental deity.

Till a system was formed, which some took advantage of & enslav'd the vulgar by attempting to realize or abstract the mental deities from their objects; thus began Priesthood.

Choosing forms of worship from poetic tales.

And at length they pronounc'd that the Gods had order'd such things.

Thus men forgot that All deities reside in the human breast.

A Memorable Fancy.

The Prophets Isaiah and Ezekiel dined with me, and I asked them how they dared so roundly to assert. that God spoke to them; and whether they did not think at the time, that they would be mis-understood, & so be the cause of imposition?

Isaiah answerd. I saw no God. nor heard any, in a finite organical perception; but my senses discoverd the infinite in every thing, and as I was then perswaded, & remain confirm'd; that the voice of honest indignation is the voice of God, I cared not for consequences but wrote.

Then I asked: does a firm perswasion that a thing is so, make it so?

He replied. All poets believe that it does, & in ages of imagination this firm perswasion removed mountains; but many are not capable of a firm perswasion of any thing.

Then Ezekiel said. The philosophy of the east taught the first principles of human perception some nations held one principle for the origin & some another. we of Israel taught that the Poetic Genius (as you now call it) was the first principle and all the others merely derivative, which was the cause of our despising the Priests & Philosophers of other countries, and prophecying that all Gods would

would at last be proved to originate in ours & to be the tributaries of the Poetic Genius, it was this. that our great poet King David desired so fervently & invokes so pathetic'ly, saying by this he conquers enemies & governs kingdoms; and we so loved our God, that we cursed in his name all the deities of surrounding nations, and asserted that they had rebelled; from these opinions the vulgar came to think that all nations would at last be subject to the jews.

This said he, like all firm perswasions, is come to pass. for all nations believe the jews code and worship the jews god, and what greater subjection can be

I heard this with some wonder, & must confess my own conviction. After dinner I ask'd Isaiah to favour the world with his lost works, he said none of equal value was lost. Ezekiel said the same of his.

I also asked Isaiah what made him go naked and barefoot three years? he answerd, the same that made our friend Diogenes the Grecian.

I then asked Ezekiel. why he eat dung, & lay so long on his right & left side? he answerd, the desire of raising other men into a perception of the infinite this the North American tribes practise. & is he honest who resists his genius or conscience. only for the sake of present ease or gratification?

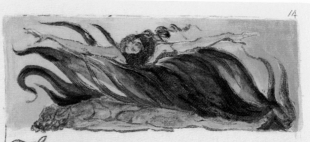

The ancient tradition that the world will be consumed in fire at the end of six thousand years is true, as I have heard from Hell,

For the cherub with his flaming sword is hereby commanded to leave his guard at tree of life, and when he does, the whole creation will be consumed, and appear infinite, and holy whereas it now appears finite & corrupt.

This will come to pass by an improvement of sensual enjoyment.

But first the notion that man has a body distinct from his soul, is to be expunged; this I shall do, by printing in the infernal method, by corrosives, which in Hell are salutary and medicinal, melting apparent surfaces away, and displaying the infinite which was hid.

If the doors of perception were cleansed every thing would appear to man as it is, infinite.

For man has closed himself up, till he sees all things thro' narrow chinks of his cavern.

A Memorable Fancy

I was in a Printing house in Hell & saw the method in which knowledge is transmitted from gene-ration to generation.

In the first chamber was a Dragon-Man, clearing away the rubbish from a caves mouth: within, a number of Dragons were hollowing the cave.

In the second chamber was a Viper folding round the rock & the cave, and others adorning it with gold silver and precious stones.

In the third chamber was an Eagle with wings and feathers of air, he caused the inside of the cave to be infinite, around were numbers of Eagle like men, who built palaces in the immense cliffs.

In the fourth chamber were Lions of flaming fire raging around & melting the metals into living fluids.

In the fifth chamber were Unnamd forms, which cast the metals into the expanse.

There they were reciev'd by Men who occupied the sixth chamber, and took the forms of books & were arranged in libraries.

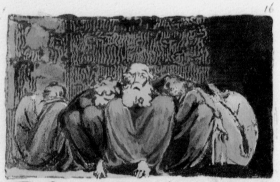

The Giants who formed this world into its
sensual existence and now seem to live in it
in chains are in truth. the causes of its life
& the sources of all activity, but the chains
are, the cunning of weak and tame minds. which
have power to resist energy, according to the pro
verb. the weak in courage is strong in cunning.
Thus one portion of being, is the Prolific. the
other. the Devouring: to the devourer it seems as
if the producer was in his chains. but it is not so
he only takes portions of existence and fancies
that the whole. —

But the Prolific would cease to be Prolific
unless the Devourer as a sea recieved the excess
of his delights.

Some will say. Is not God alone the Prolific
I answer. God only Acts & Is. in existing beings
or Men. —

These two classes of men are always upon
earth. & they should be enemies; whoever tries
to

to reconcile them seeks to destroy existence.

Religion is an endeavour to reconcile the two.

Note. Jesus Christ did not wish to unite but to seperate them, as in the Parable of sheep and goats! & he says I came not to send Peace but a Sword.

Messiah or Satan or Tempter was formerly thought to be one of the Antediluvians who are our Energies.

A Memorable Fancy

An Angel came to me and said O pitiable foolish young man! O horrible! O dreadful state! consider the hot burning dungeon thou art preparing for thyself to all eternity, to which thou art going in such career. I said. perhaps you will be willing to shew me my eternal lot & we will contemplate together upon it and see whether your lot or mine is most desirable So he took me thro' a stable & thro' a church & down into the church vault at the end of which was a mill: thro' the mill we went, and came to a cave, down the winding cavern we groped our tedious way till a void boundless as a nether sky appeard beneath us & we held by the roots of trees and hung over this immensity, but I said, if you please we will commit ourselves to this void, and see whether providence is here also, if you will not I will? but he answerd, do not presume O young man but as we here remain behold thy lot which will soon appear when the darkness passes away So I remaind with him sitting in the twisted root

root of an oak. he was s-spended in a fungus
which hung with the head downward into the deep:
 By degrees we beheld the infinite Abyss. fiery
as the smoke of a burning city; beneath us at an
immense distance was the sun. black but shining
round it were fiery tracks on which revolvd vast
spiders. crawling after their prey; which flew or
rather swum in the infinite deep, in the most ter-
-rific shapes of animals sprung from corruption.
& the air was full of them, & seemd composed
of them; these are Devils. and are called Powers
of the air. I now asked my companion which was my
eternal lot? he said. between the black & white spiders

 But now. from between the black & white spiders
a cloud and fire burst and rolled thro the deep
blackning all beneath, so that the nether deep grew
black as a sea & rolled with a terrible noise: be-
neath us was nothing now to be seen but a black
tempest, till looking east between the clouds & the
waves. we saw a cataract of blood mixed with fire
and not many stones throw from us appeard and
sunk again the scaly fold of a monstrous serpent
at last to the east, distant about three degrees ap-
peard a fiery crest above the waves slowly it rear-
ed like a ridge of golden rocks till we discoverd
two globes of crimson fire, from which the sea
fled away in clouds of smoke, and now we saw, it
was the head of Leviathan. his forehead was di-
vided into streaks of green & purple like those on
a tygers forehead: soon we saw his mouth & red
gills hang just above the raging foam tinging the
black deep with beams of blood. advancing toward

us with all the fury of a spiritual existence.

~My friend the Angel climb'd up from his station into the mill; I remaind alone. & then this appearance was no more, but I found myself sitting on a pleasant bank beside a river by moon light hearing a harper who sung to the harp. & his theme was, The man who never alters his opinion is like standing water. & breeds reptiles of the mind.

But I arose. and sought for the mill & there I found my Angel, who surprised asked me. how I escaped?

~ I answerd. All that we saw was owing to your metaphysics: for when you ran away, I found myself on a bank by moonlight hearing a harper, But now we have seen my eternal lot. shall I shew you yours? he laughd at my proposal: but I by force suddenly caught him in my arms, & flew westerly thro' the night. till we were elevated above the earths shadow: then I flung myself with him directly into the body of the sun, here I clothed myself in white, & taking in my hand Swedenborgs volumes sunk from the glorious clime, and passed all the planets till we came to saturn, here I staid to rest & then leapd into the void. between saturn & the fixed stars.

Here said I! is your lot, in this space, if space it may be calld. Soon we saw the stable and the church, & I took him to the altar and opend the Bible, and lo! it was a deep pit, into which I descended driving the Angel before me, soon we saw seven houses of brick. one we enterd; in it were a num

number of monkeys, baboons, & all of that species chaind by the middle, grinning and snatching at one another, but witheld by the shortness of their chains: however I saw that they sometimes grew numerous, and then the weak were caught by the strong and with a grinning aspect, first coupled with & then devourd, by plucking off first one limb and then another till the body was left a helpless trunk. this after grinning & kissing it with seeming fondness they devourd too; and here & there I saw one go slily picking the flesh off of his own tail; as the stench terribly annoyd us both we went into the mill, & I in my hand brought the skeleton of a body, which in the mill was Aristotles Analytics.

So the Angel said: thy phantasy has imposed upon me & thou oughtest to be ashamed.

I answerd: we impose on one another, & it is but lost time to converse with you whose works are only Analytics

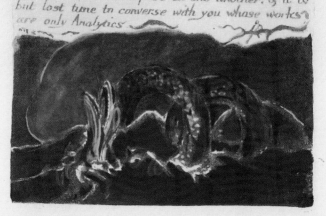

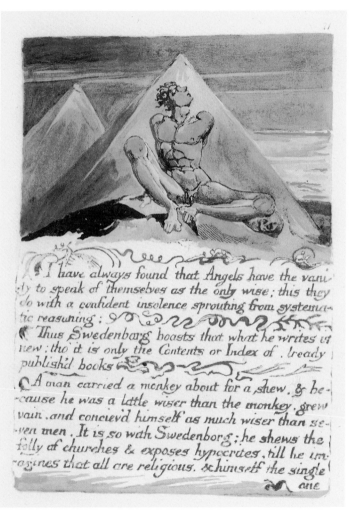

I have always found that Angels have the vani
ty to speak of themselves as the only wise: this they
do with a confident insolence sprouting from systema-
tic reasoning:

Thus Swedenborg boasts that what he writes is
new: tho it is only the Contents or Index of already
publishd books

A man carried a monkey about for a shew, & be
-cause he was a little wiser than the monkey, grew
vain, and concievd himself as much wiser than se-
-ven men. It is so with Swedenborg: he shews the
folly of churches & exposes hypocrites, till he im-
agines that all are religious, & himself the single

one

one on earth that ever broke a net.

Now hear a plain fact: Swedenborg has not writ-
ten one new truth: Now hear another: he has written
all the old falshoods

And now hear the reason. He conversed with Angels
who are all religious. & conversed not with Devils who
all hate religion, for he was incapable thro' his conceited
notions.

Thus Swedenborgs writings are a recapitulation of
all superficial opinions, and an analysis of the more
sublime, but no further

Have now another plain fact: Any man of mechani-
cal talents may from the writings of Paracelsus or Ja-
cob Behmen, produce ten thousand volumes of equal
value with Swedenborgs, and from those of Dante or
Shakespear, an infinite number.

But when he has done this, let him not say that he
knows better than his master, for he only holds a can-
dle in sunshine.

A Memorable Fancy

Once I saw a Devil in a flame of fire, who arose be-
fore an Angel that sat on a cloud. and the Devil ut-
tered these words.

The worship of God is. Honouring his gifts in other
men each according to his genius. and loving the
great

greatest men best, those who envy or calumniate
great men hate God. for there is no other God.
 The Angel hearing this became almost blue
but mastering himself he grew yellow, & at last
white pink & smiling. and then replied.
 Thou Idolater, is not God One? & is not he
visible in Jesus Christ? and has not Jesus Christ
given his sanction to the law of ten commandments
and are not all other men fools, sinners, & nothings?
 The Devil answerd: bray a fool in a mortar with
wheat yet shall not his folly be beaten out of him;
if Jesus Christ is the greatest man, you ought to
love him in the greatest degree; now hear how he
has given his sanction to the law of ten command-
ments: did he not mock at the sabbath, and so
mock the sabbaths God? murder those who were
murderd because of him? turn away the law from
the woman taken in adultery? steal the labor of
others to support him? bear false witness when
he omitted making a defence before Pilate? covet
when he prayd for his disciples, and when he bid
them shake off the dust of their feet against such
as refused to lodge them? I tell you, no virtue
can exist without breaking these ten command-
ments. Jesus was all virtue, and acted from im
 -pulse

pulse, not from rules.

 When he had so spoken: I beheld the Angel who
stretched out his arms embracing the flame of fire
& he was consumed and arose as Elijah.

Note. This Angel, who is now become a Devil, is
my particular friend: we often read the Bible to-
gether in its infernal or diabolical sense which
the world shall have if they behave well.

 I have also: The Bible of Hell: which the world
shall have whether they will or no.

One Law for the Lion & Ox is Oppression

A Song of Liberty

1 The Eternal Female groan'd! it was heard over all the Earth:

2. Albions coast is sick silent: the American meadows faint!

3. Shadows of Prophecy shiver along by the lakes and the rivers and mutter across the ocean? France rend down thy dungeon

4. Golden Spain burst the barriers of old Rome;

5. Cast thy keys O Rome into the deep down falling, even to eternity down falling,

6. And weep

7. In her trembling hands she took the new born terror howling;

8. On those infinite mountains of light now barr'd out by the atlantic sea, the new born fire stood before the starry king!

9. Flag'd with grey brow'd snows and thunderous visages the jealous wings wav'd over the deep.

10. The speary hand burned aloft, unbuckled was the shield, forth went the hand of jealousy among the flaming hair, and

hurld the new born wonder thro' the starry
night.

11. The fire, the fire, is falling!

12. Look up! look up! O citizen of London.
enlarge thy countenance; O Jew, leave coun
ting gold, return to thy oil and wine; O
African! black African! (go. winged thought
widen his forehead.)

13. The fiery limbs, the flaming hair, shot
like the sinking sun into the western sea.

14. Wak'd from his eternal sleep, the hoary
element roaring fled away:

15. Down rush'd beating his wings in vain
the jealous king; his grey browd councel-
lors, thunderous warriors, curld veterans.
among helms, and shields, and chariots
horses, elephants: banners, castles, slings
and rocks,

16. Falling, rushing, ruining! buried in
the ruins, on Urthona's dens.

17. All night beneath the ruins, then
their sullen flames faded emerge roun.
the gloomy king.

18. With thunder and fire: leading his
starry hosts thro' the waste wilderness

he promulgates his ten comands. glancing his beamy eyelids over the deep in dark dismay,

19. Where the son of fire in his eastern cloud, while the morning plumes her golden breast.

20. Spurning the clouds written with curses, stamps the stony law to dust, loosing the eternal horses from the dens of night, crying Empire is no more! and now the lion & wolf shall cease.

Chorus

Let the Priests of the Raven of dawn, no longer in deadly black, with hoarse note curse the sons of joy. Nor his accepted brethren whom tyrant. he calls free: lay the bound or build the roof, Nor pale religious letchery call that virginity, that wishes but acts not!

For every thing that lives is Holy

THE MARRIAGE of HEAVEN and HELL

[Plate 1]

THE ARGUMENT.

[Plate 2]

Rintrah roars & shakes his fires in the burden'd air;
Hungry clouds swag on the deep.

Once meek, and in a perilous path,
The just man kept his course along
The vale of death.
Roses are planted where thorns grow,
And on the barren heath
Sing the honey bees.

Then the perilous path was planted:
And a river and a spring
On every cliff and tomb;
And on the bleached bones
Red clay brought forth.

Till the villain left the paths of ease,
To walk in perilous paths, and drive
The just man into barren climes.

Now the sneaking serpent walks
In mild humility,
And the just man rages in the wilds
Where lions roam.

Rintrah roars & shakes his fires in the burden'd air:
Hungry clouds swag on the deep.

[*Plate 3*]

As a new heaven is begun, and it is now thirty-three years since its advent: the Eternal Hell revives. And lo! Swedenborg is the Angel sitting at the tomb: his writings are the linen clothes folded up. Now is the dominion of Edom, & the return of Adam into Paradise; see Isaiah XXXIV & XXXV Chap:

Without Contraries is no progression. Attraction and Repulsion, Reason and Energy, Love and Hate, are necessary to Human existence.

From these contraries spring what the religious call Good & Evil. Good is the passive that obeys Reason. Evil is the active springing from Energy.

Good is Heaven. Evil is Hell.

THE VOICE OF THE DEVIL
[*Plate 4*]

All Bibles or sacred codes, have been the causes of the following Errors.

1. That Man has two real existing principles Viz: a Body & a Soul.

2. That Energy, call'd Evil, is alone from the Body, & that Reason, call'd Good, is alone from the Soul.

3. That God will torment Man in Eternity for following his Energies.

But the following Contraries to these are True.

1. Man has no Body distinct from his Soul; for that call'd Body is a portion of Soul discern'd by the five Senses, the chief inlets of Soul in this age.

2. Energy is the only life and is from the Body and Reason is the bound or outward circumference of Energy.

3. Energy is Eternal Delight.

Those who restrain desire, do so because theirs is weak enough to be restrained; and the restrainer or reason usurps its place & governs the unwilling.

And being restrain'd it by degrees becomes passive till it is only the shadow of desire.

The history of this is written in Paradise Lost, & the Governor or Reason is call'd Messiah.

And the original Archangel or possessor of the command of the heavenly host, is call'd the Devil or Satan and his children are call'd Sin & Death.

But in the Book of Job Miltons Messiah is call'd Satan.

For this history has been adopted by both parties.

It indeed appear'd to Reason as if Desire was cast out, but the Devils account is that the Messiah fell, & formed a heaven of what he stole from the Abyss.

This is shewn in the Gospel, where he prays to the Father to send the comforter or Desire that Reason may have Ideas to build on, the Jehovah of the Bible being no other than he who dwells in flaming fire.

Know that after Christs death, he became Jehovah.

But in Milton; the Father is Destiny, the Son, a Ratio of the five senses, & the Holy-ghost, Vacuum!

Note. The reason Milton wrote in fetters when he wrote of Angels & God, and at liberty when of Devils & Hell, is because he was a true Poet and of the Devils party without knowing it.

A MEMORABLE FANCY
[Plates 6–7]

As I was walking among the fires of hell, delighted with the enjoyments of Genius; which to Angels look like torment and insanity, I collected some of their Proverbs; thinking that as the sayings used in a nation, mark its character, so the Proverbs of Hell, shew the nature of

Infernal wisdom better than any description of buildings or garments.

When I came home: on the abyss of the five senses, where a flat sided steep frowns over the present world, I saw a mighty Devil folded in black clouds, hovering on the sides of the rock, with corroding fires he wrote the following sentence now percieved by the minds of men, & read by them on earth.

> How do you know but ev'ry Bird that cuts the airy way,
> Is an immense world of delight, clos'd by your senses five?

PROVERBS OF HELL
[*Plate 7*]

In seed time learn, in harvest teach, in winter enjoy.
Drive your cart and your plow over the bones of the dead.
The road of excess leads to the palace of wisdom.
Prudence is a rich ugly old maid courted by Incapacity.
He who desires but acts not, breeds pestilence.
The cut worm forgives the plow.
Dip him in the river who loves water.
A fool sees not the same tree that a wise man sees.
He whose face gives no light, shall never become a star.
Eternity is in love with the productions of time.
The busy bee has no time for sorrow.
The hours of folly are measur'd by the clock, but of wisdom: no clock
 can measure.
All wholsom food is caught without a net or a trap.
Bring out number weight & measure in a year of dearth.
No bird soars too high, if he soars with his own wings.
A dead body, revenges not injuries.
The most sublime act is to set another before you.
If the fool would persist in his folly he would become wise.
Folly is the cloke of knavery.
Shame is Prides cloke.

PROVERBS OF HELL
[*Plate 8*]

Prisons are built with stones of Law, Brothels with bricks of Religion.

The pride of the peacock is the glory of God.

The lust of the goat is the bounty of God.

The wrath of the lion is the wisdom of God.

The nakedness of woman is the work of God.

Excess of sorrow laughs. Excess of joy weeps.

The roaring of lions, the howling of wolves, the raging of the stormy sea, and the destructive sword, are portions of eternity too great for the eye of man.

The fox condemns the trap, not himself.

Joys impregnate. Sorrows bring forth.

Let man wear the fell of the lion, woman the fleece of the sheep.

The bird a nest, the spider a web, man friendship.

The selfish smiling fool, & the sullen frowning fool, shall be both thought wise, that they may be a rod.

What is now proved was once, only imagin'd.

The rat, the mouse, the fox, the rabbet: watch the roots; the lion, the tyger, the horse, the elephant, watch the fruits.

The cistern contains; the fountain overflows.

One thought, fills immensity.

Always be ready to speak your mind, and a base man will avoid you.

Every thing possible to be believ'd is an image of truth.

The eagle never lost so much time, as when he submitted to learn of the crow.

PROVERBS OF HELL
[*Plate 9*]

The fox provides for himself, but God provides for the lion.

Think in the morning. Act in the noon. Eat in the evening. Sleep in the night.

He who has suffer'd you to impose on him knows you.

As the plow follows words, so God rewards prayers.

The tygers of wrath are wiser than the horses of instruction.

Expect poison from the standing water.

You never know what is enough unless you know what is more than enough.

Listen to the fools reproach! it is a kingly title!

The eyes of fire, the nostrils of air, the mouth of water, the beard of earth.

The weak in courage is strong in cunning.

The apple tree never asks the beech how he shall grow, nor the lion, the horse, how he shall take his prey.

The thankful reciever bears a plentiful harvest.

If others had not been foolish, we should be so.

The soul of sweet delight, can never be defil'd.

When thou seest an Eagle, thou seest a portion of Genius, lift up thy head!

As the catterpiller chooses the fairest leaves to lay her eggs on, so the priest lays his curse on the fairest joys.

To create a little flower is the labour of ages.

Damn, braces: Bless relaxes.

The best wine is the oldest, the best water the newest.

Prayers plow not! Praises reap not!

Joys laugh not! Sorrows weep not!

PROVERBS OF HELL

[*Plate 10*]

The head Sublime, the heart Pathos, the genitals Beauty, the hands & feet Proportion.

As the air to a bird or the sea to a fish, so is contempt to the contemptible.

The crow wish'd every thing was black, the owl, that every thing was
white.

Exuberance is Beauty.

If the lion was advised by the fox, he would be cunning.

Improve[me]nt makes strait roads, but the crooked roads without
Improvement, are roads of Genius.

Sooner murder an infant in its cradle than nurse unacted desires.

Where man is not nature is barren.

Truth can never be told so as to be understood, and not be believ'd.

Enough! or Too much.

[Plate 11]

The ancient Poets animated all sensible objects with Gods or
Geniuses, calling them by the names and adorning them with the
properties of woods, rivers, mountains, lakes, cities, nations, and
whatever their enlarged & numerous senses could percieve.

And particularly they studied the genius of each city & country,
placing it under its mental deity.

Till a system was formed, which some took advantage of & enslav'd
the vulgar by attempting to realize or abstract the mental deities from
their objects; thus began Priesthood.

Choosing forms of worship from poetic tales.

And at length they pronounc'd that the Gods had order'd such things.

Thus men forgot that All deities reside in the human breast.

A MEMORABLE FANCY.

[Plates 12–13]

The Prophets Isaiah and Ezekiel dined with me, and I asked them
how they dared so roundly to assert, that God spoke to them; and
whether they did not think at the time, that they would be misun-
derstood, & so be the cause of imposition.

Isaiah answer'd, I saw no God, nor heard any, in a finite organical perception; but my senses discover'd the infinite in every thing, and as I was then perswaded, & remain confirm'd; that the voice of honest indignation is the voice of God, I cared not for consequences but wrote.

Then I asked: does a firm perswasion that a thing is so, make it so?

He replied, All poets believe that it does, & in ages of imagination this firm perswasion removed mountains; but many are not capable of a firm perswasion of any thing.

Then Ezekiel said, The philosophy of the east taught the first principles of human perception: some nations held one principle for the origin & some another; we of Israel taught that the Poetic Genius (as you now call it) was the first principle and all the others merely derivative, which was the cause of our despising the Priests & Philosophers of other countries, and prophecying that all Gods would at last be proved to originate in ours & to be the tributaries of the Poetic Genius; it was this that our great poet King David desired so fervently & invokes so patheticly, saying by this he conquers enemies & governs kingdoms; and we so loved our God, that we cursed in his name all the deities of surrounding nations, and asserted that they had rebelled; from these opinions the vulgar came to think that all nations would at last be subject to the jews.

This said he, like all firm perswasions, is come to pass, for all nations believe the jews code and worship the jews god, and what greater subjection can be?

I heard this with some wonder, & must confess my own conviction. After dinner I ask'd Isaiah to favour the world with his lost works, he said none of equal value was lost. Ezekiel said the same of his.

I also asked Isaiah what made him go naked and barefoot three years? he answer'd, the same that made our friend Diogenes the Grecian.

I then asked Ezekiel, why he eat dung, & lay so long on his right & left side? he answer'd, the desire of raising other men into a perception of the infinite; this the North American tribes practise, & is he honest who resists his genius or conscience only for the sake of present ease or gratification?

[*Plate 14*]

The ancient tradition that the world will be consumed in fire at the end of six thousand years is true, as I have heard from Hell.

For the cherub with his flaming sword is hereby commanded to leave his guard at tree of life, and when he does, the whole creation will be consumed, and appear infinite, and holy whereas it now appears finite & corrupt.

This will come to pass by an improvement of sensual enjoyment.

But first the notion that man has a body distinct from his soul, is to be expunged: this I shall do, by printing in the infernal method, by corrosives, which in Hell are salutary and medicinal, melting apparent surfaces away, and displaying the infinite which was hid.

If the doors of perception were cleansed every thing would appear to man as it is, infinite.

For man has closed himself up, till he sees all things thro' narrow chinks of his cavern.

A MEMORABLE FANCY

[*Plate 15*]

I was in a Printing house in Hell & saw the method in which knowledge is transmitted from generation to generation.

In the first chamber was a Dragon-Man, clearing away the rubbish from a caves mouth; within, a number of Dragons were hollowing the cave.

In the second chamber was a Viper folding round the rock & the cave, and others adorning it with gold, silver and precious stones.

In the third chamber was an Eagle with wings and feathers of air; he caused the inside of the cave to be infinite; around were numbers of Eagle like men, who built palaces in the immense cliffs.

In the fourth chamber were Lions of flaming fire raging around & melting the metals into living fluids.

In the fifth chamber were Unnam'd forms, which cast the metals into the expanse.

There they were reciev'd by Men who occupied the sixth chamber, and took the forms of books & were arranged in libraries.

[Plates 16–17]

The Giants who formed this world into its sensual existence and now seem to live in it in chains, are in truth, the causes of its life & the sources of all activity; but the chains are, the cunning of weak and tame minds, which have power to resist energy, according to the proverb, the weak in courage is strong in cunning.

Thus one portion of being, is the Prolific, the other, the Devouring: to the devourer it seems as if the producer was in his chains, but it is not so; he only takes portions of existence and fancies that the whole.

But the Prolific would cease to be Prolific unless the Devourer as a sea recieved the excess of his delights.

Some will say, Is not God alone the Prolific? I answer, God only Acts & Is, in existing beings or Men.

These two classes of men are always upon earth, & they should be enemies; whoever tries to reconcile them seeks to destroy existence.

Religion is an endeavour to reconcile the two.

Note. Jesus Christ did not wish to unite but to seperate them, as in the Parable of sheep and goats! & he says I came not to send Peace but a Sword.

Messiah or Satan or Tempter was formerly thought to be one of the Antediluvians who are our Energies.

A MEMORABLE FANCY
[Plates 17–20]

An Angel came to me and said O pitiable foolish young man! O horrible! O dreadful state! consider the hot burning dungeon thou art

preparing for thyself to all eternity, to which thou art going in such career.

I said, perhaps you will be willing to shew me my eternal lot & we will contemplate together upon it and see whether your lot or mine is most desirable.

So he took me thro' a stable & thro' a church & down into the church vault at the end of which was a mill: thro' the mill we went, and came to a cave, down the winding cavern we groped our tedious way till a void boundless as a nether sky appear'd beneath us, & we held by the roots of trees and hung over this immensity, but I said, if you please we will commit ourselves to this void, and see whether providence is here also, if you will not, I will? but he answer'd, do not presume O young-man but as we here remain behold thy lot which will soon appear when the darkness passes away.

So I remain'd with him sitting in the twisted root of an oak; he was suspended in a fungus, which hung with the head downward into the deep.

By degrees we beheld the infinite Abyss, fiery as the smoke of a burning city; beneath us at an immense distance was the sun, black but shining; round it were fiery tracks on which revolv'd vast spiders, crawling after their prey; which flew or rather swum in the infinite deep, in the most terrific shapes of animals sprung from corruption, & the air was full of them, & seem'd composed of them; these are Devils, and are called Powers of the air. I now asked my companion which was my eternal lot? he said, between the black & white spiders.

But now, from between the black & white spiders, a cloud and fire burst and rolled thro' the deep, blackning all beneath, so that the nether deep grew black as a sea & rolled with a terrible noise; beneath us was nothing now to be seen but a black tempest, till looking east between the clouds & the waves, we saw a cataract of blood mixed with fire, and not many stones throw from us appear'd and sunk again the scaly fold of a monstrous serpent; at last to the east, distant about three degrees appear'd a fiery crest above the waves; slowly it reared like a ridge of golden rocks till we discover'd two globes of crimson fire, from which

the sea fled away in clouds of smoke, and now we saw, it was the head of Leviathan; his forehead was divided into streaks of green & purple like those on a tygers forehead: soon we saw his mouth & red gills hang just above the raging foam tinging the black deep with beams of blood, advancing toward us with all the fury of a spiritual existence.

My friend the Angel climb'd up from his station into the mill; I remain'd alone, & then this appearance was no more, but I found myself sitting on a pleasant bank beside a river by moonlight hearing a harper who sung to the harp, & his theme was, The man who never alters his opinion is like standing water, & breeds reptiles of the mind.

But I arose, and sought for the mill & there I found my Angel, who surprised asked me how I escaped?

I answer'd, All that we saw was owing to your metaphysics; for when you ran away, I found myself on a bank by moonlight hearing a harper. But now we have seen my eternal lot, shall I shew you yours? he laugh'd at my proposal; but I by force suddenly caught him in my arms, & flew westerly thro' the night, till we were elevated above the earths shadow; then I flung myself with him directly into the body of the sun; here I clothed myself in white, & taking in my hand Swedenborgs volumes, sunk from the glorious clime, and passed all the planets till we came to saturn; here I staid to rest, & then leap'd into the void, between saturn & the fixed stars.

Here, said I! is your lot, in this space, if space it may be call'd. Soon we saw the stable and the church, & I took him to the altar and open'd the Bible, and lo! it was a deep pit, into which I descended driving the Angel before me; soon we saw seven houses of brick; one we enter'd; in it were a number of monkeys, baboons, & all of that species, chain'd by the middle, grinning and snatching at one another, but witheld by the shortness of their chains; however I saw that they sometimes grew numerous, and then the weak were caught by the strong, and with a grinning aspect, first coupled with & then devour'd, by plucking off first one limb and then another till the body was left a helpless trunk; this after grinning & kissing it with seeming fondness they devour'd too; and here & there I saw one savourily picking the flesh off of his own tail; as

the stench terribly annoy'd us both we went into the mill, & I in my hand brought the skeleton of a body, which in the mill was Aristotles Analytics.

So the Angel said: thy phantasy has imposed upon me & thou oughtest to be ashamed.

I answer'd: we impose on one another, & it is but lost time to converse with you whose works are only Analytics.

<p style="text-align:center">Opposition is true Friendship.</p>

<p style="text-align:center">[Plates 21–22]</p>

I have always found that Angels have the vanity to speak of themselves as the only wise; this they do with a confident insolence sprouting from systematic reasoning:

Thus Swedenborg boasts that what he writes is new; tho' it is only the Contents or Index of already publish'd books.

A man carried a monkey about for a shew, & because he was a little wiser than the monkey, grew vain, and conciev'd himself as much wiser than seven men. It is so with Swedenborg; he shews the folly of churches & exposes hypocrites, till he imagines that all are religious, & himself the single one on earth that ever broke a net.

Now hear a plain fact: Swedenborg has not written one new truth: Now hear another: he has written all the old falshoods.

And now hear the reason. He conversed with Angels who are all religious, & conversed not with Devils who all hate religion, for he was incapable thro' his conceited notions.

Thus Swedenborgs writings are a recapitulation of all superficial opinions, and an analysis of the more sublime, but no further.

Have now another plain fact: Any man of mechanical talents may from the writings of Paracelsus or Jacob Behmen, produce ten thousand volumes of equal value with Swedenborgs, and from those of Dante or Shakespear, an infinite number.

But when he has done this, let him not say that he knows better than his master, for he only holds a candle in sunshine.

A MEMORABLE FANCY

[*Plates 22–24*]

Once I saw a Devil in a flame of fire, who arose before an Angel that sat on a cloud, and the Devil utter'd these words.

The worship of God is, Honouring his gifts in other men each according to his genius, and loving the greatest men best; those who envy or calumniate great men hate God, for there is no other God.

The Angel hearing this became almost blue, but mastering himself he grew yellow, & at last white pink & smiling, and then replied,

Thou Idolater, is not God One? & is not he visible in Jesus Christ? and has not Jesus Christ given his sanction to the law of ten commandments, and are not all other men fools, sinners, & nothings?

The Devil answer'd: bray a fool in a morter with wheat, yet shall not his folly be beaten out of him; if Jesus Christ is the greatest man, you ought to love him in the greatest degree; now hear how he has given his sanction to the law of ten commandments: did he not mock at the sabbath, and so mock the sabbaths God? murder those who were murder'd because of him? turn away the law from the woman taken in adultery? steal the labor of others to support him? bear false witness when he omitted making a defence before Pilate? covet when he pray'd for his disciples, and when he bid them shake off the dust of their feet against such as refused to lodge them? I tell you, no virtue can exist without breaking these ten commandments; Jesus was all virtue, and acted from impulse, not from rules.

When he had so spoken: I beheld the Angel who stretched out his arms embracing the flame of fire, & he was consumed and arose as Elijah.

Note. This Angel, who is now become a Devil, is my particular friend; we often read the Bible together in its infernal or diabolical sense which the world shall have if they behave well.

I have also: The Bible of Hell: which the world shall have whether they will or no.

<div style="text-align:center">

One Law for the Lion & Ox is Oppression.

</div>

A SONG OF LIBERTY

[Plates 25–27]

1. The Eternal Female groan'd! it was heard over all the Earth:

2. Albions coast is sick silent; the American meadows faint!

3. Shadows of Prophecy shiver along by the lakes and the rivers and mutter across the ocean. France rend down thy dungeon;

4. Golden Spain burst the barriers of old Rome;

5. Cast thy keys O Rome into the deep down falling, even to eternity down falling,

6. And weep.

7. In her trembling hands she took the new born terror howling;

8. On those infinite mountains of light, now barr'd out by the atlantic sea, the new born fire stood before the starry king!

9. Flag'd with grey brow'd snows and thunderous visages the jealous wings wav'd over the deep.

10. The speary hand burned aloft, unbuckled was the shield, forth went the hand of jealousy among the flaming hair, and hurl'd the new born wonder thro' the starry night.

11. The fire, the fire, is falling!

12. Look up! look up! O citizen of London, enlarge thy countenance; O Jew, leave counting gold! return to thy oil and wine; O African! black African! (go, winged thought, widen his forehead.)

13. The fiery limbs, the flaming hair, shot like the sinking sun into the western sea.

14. Wak'd from his eternal sleep, the hoary element roaring fled away;

15. Down rush'd beating his wings in vain the jealous king; his grey brow'd councellors, thunderous warriors, curl'd veterans, among helms, and shields, and chariots, horses, elephants: banners, castles, slings, and rocks,

16. Falling, rushing, ruining! buried in the ruins, on Urthona's dens;

17. All night beneath the ruins, then their sullen flames faded emerge round the gloomy King.

18. With thunder and fire: leading his starry hosts thro' the waste

wilderness, he promulgates his ten commands, glancing his beamy eyelids over the deep in dark dismay,

19. Where the son of fire in his eastern cloud, while the morning plumes her golden breast,

20. Spurning the clouds written with curses, stamps the stony law to dust, loosing the eternal horses from the dens of night, crying,

Empire is no more! and now the lion & wolf shall cease.

Chorus

Let the Priests of the Raven of dawn, no longer in deadly black, with hoarse note curse the sons of joy. Nor his accepted brethren, whom tyrant, he calls free: lay the bound or build the roof. Nor pale religious letchery call that virginity, that wishes but acts not!

For every thing that lives is Holy.